JUST SAY IT! NOTEBOOK

Copyrighted 2020 © by Anonymous

www.ingramcontent.com/pod-product-compliance
Lightning Source LLC
Chambersburg PA
CBHW082015230526
45468CB00022B/2283